This Notebook belongs to:

I am grateful for my life

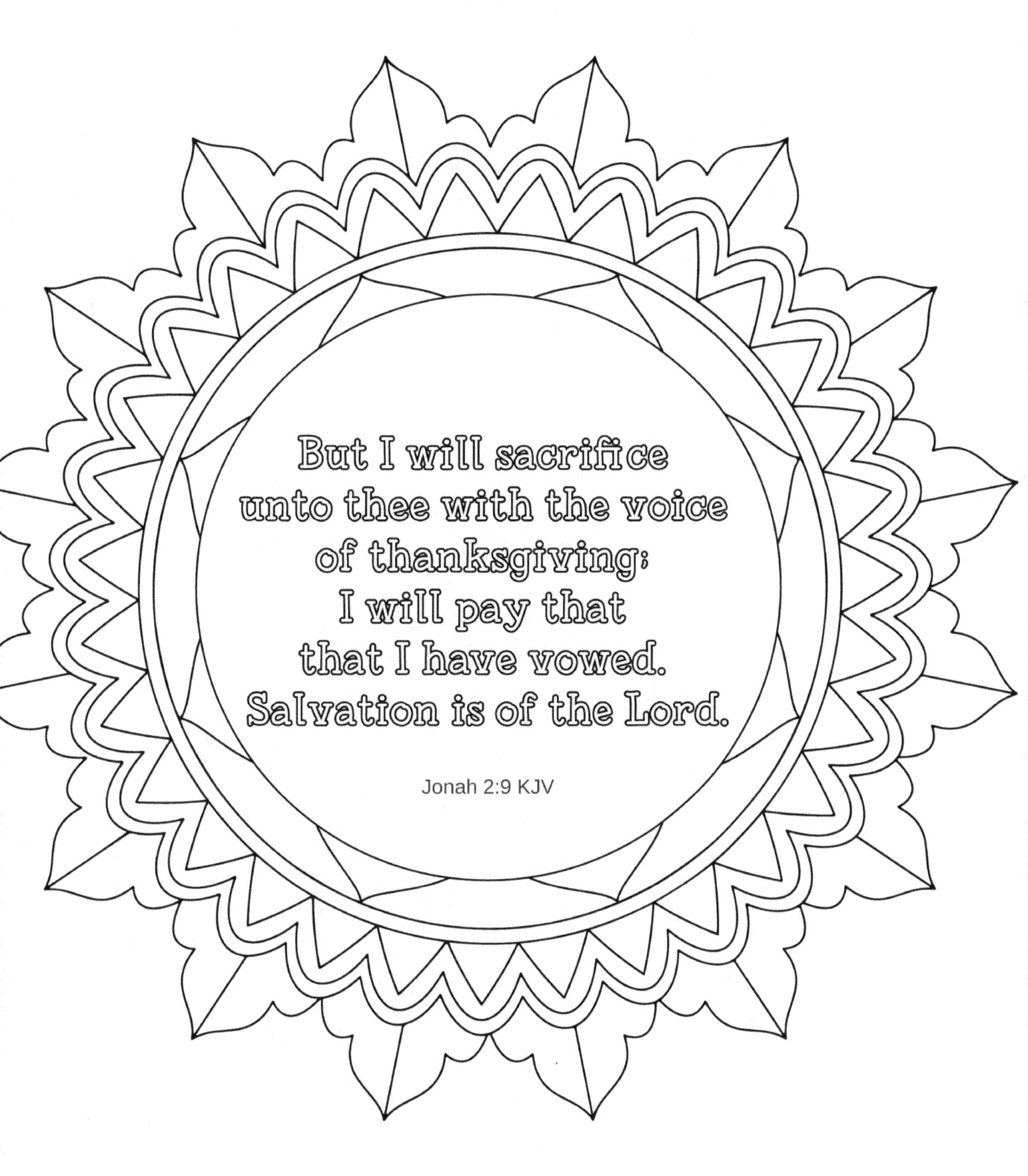

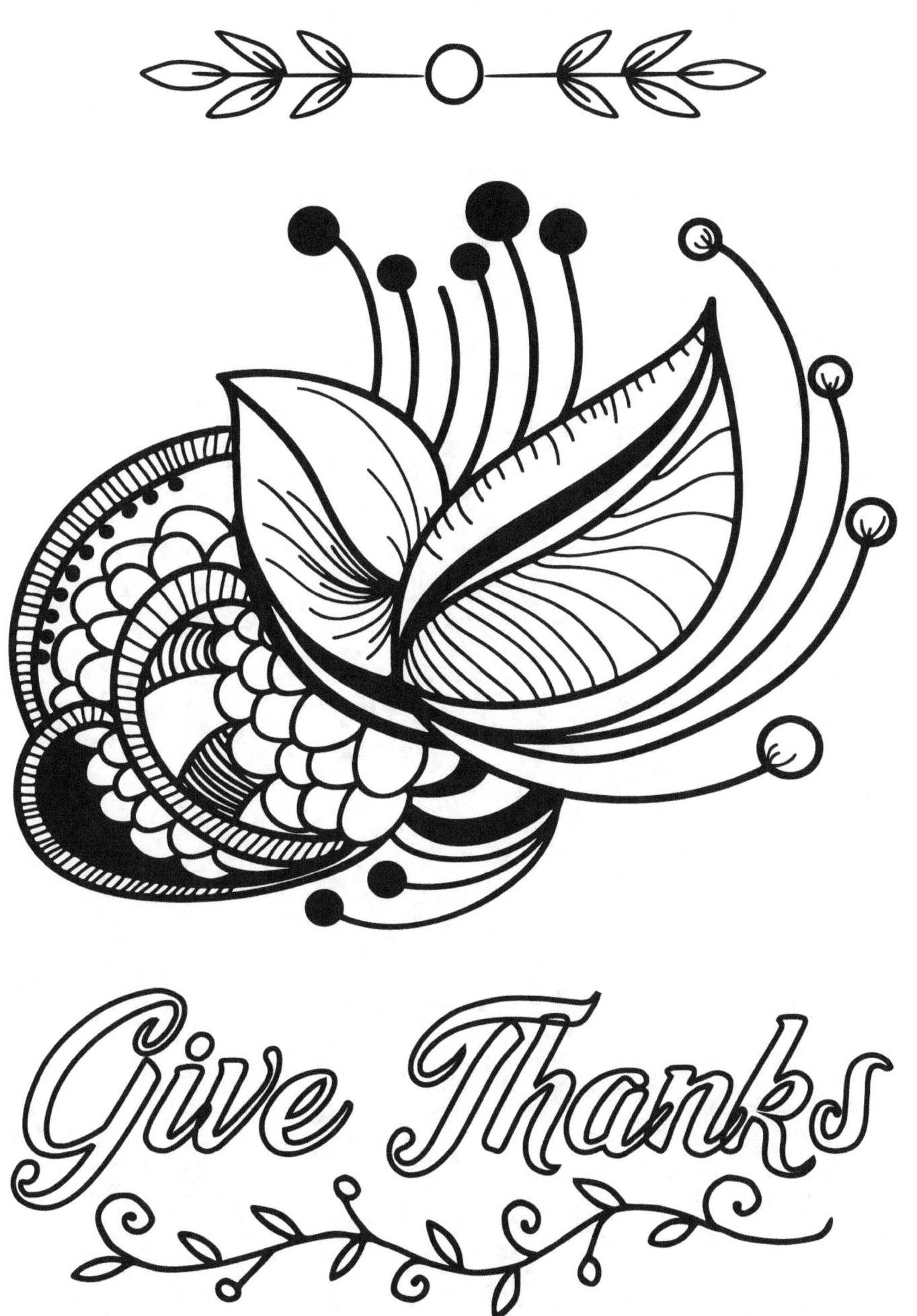

AM GRATEFUL FOR YOU, GOD, FOR YOUR LOVE, GRACE, GIFTS AND BLESSINGS.

Have a grateful heart

BE GRATEFUL EVERY DAY

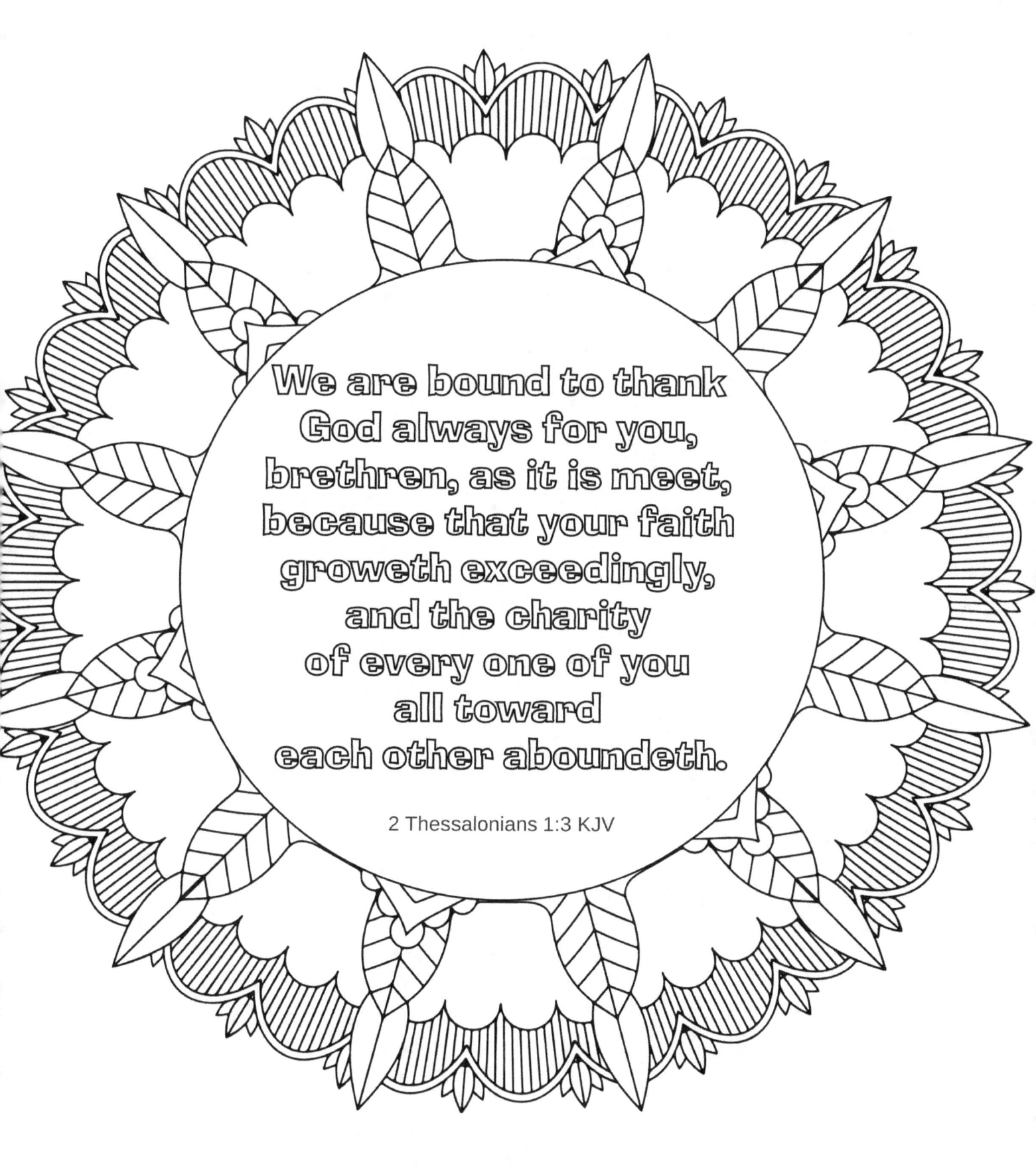

We are bound to thank God always for you, brethren, as it is meet, because that your faith groweth exceedingly, and the charity of every one of you all toward each other aboundeth.

2 Thessalonians 1:3 KJV

I am grateful

for what I have

I am grateful for my loving and supporting family, relatives and friends.

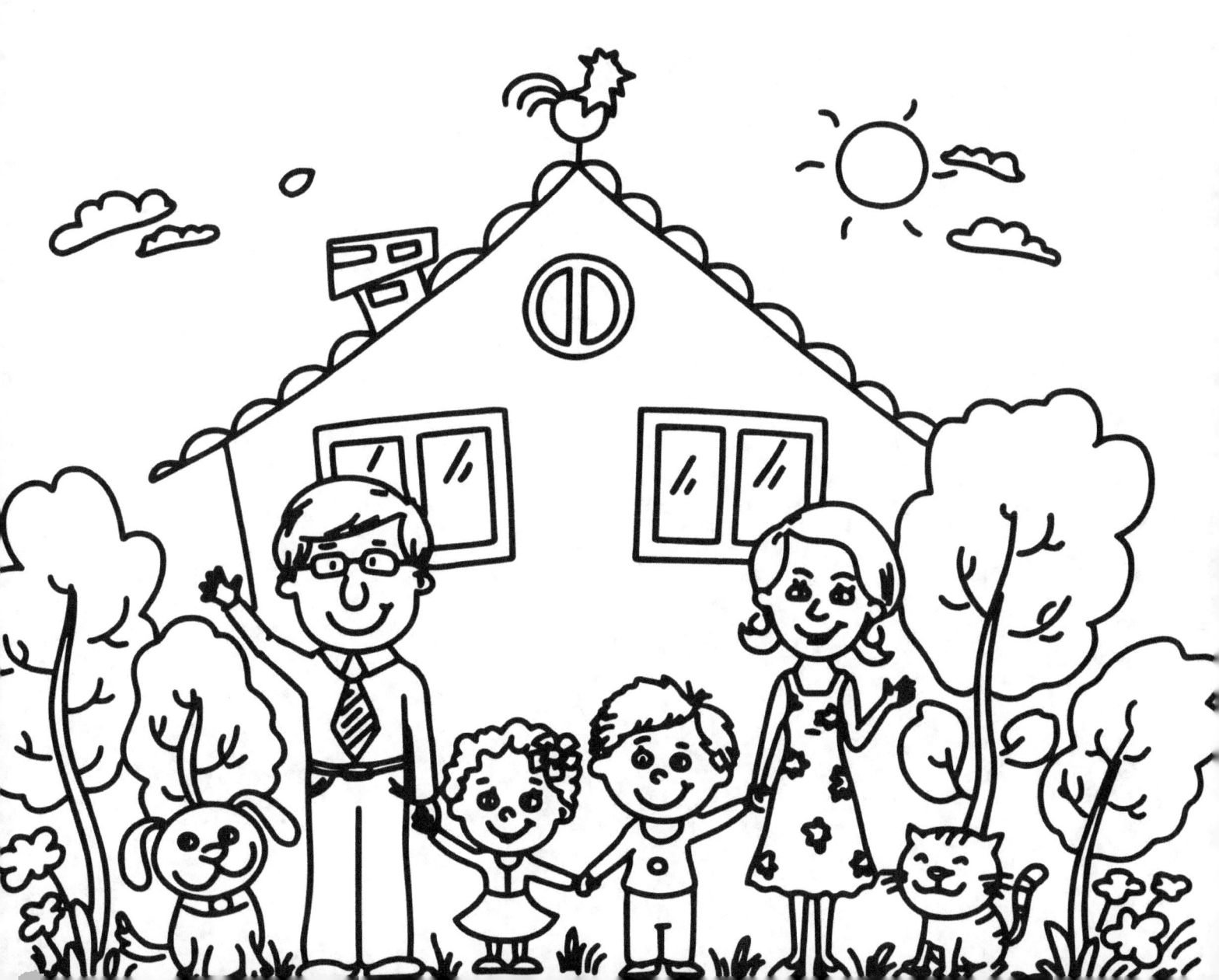

Be thankful for your blessings

Fill Your Heart With Gratitude

I am grateful for my health, abundance, happiness, success and prosperity

MAZE

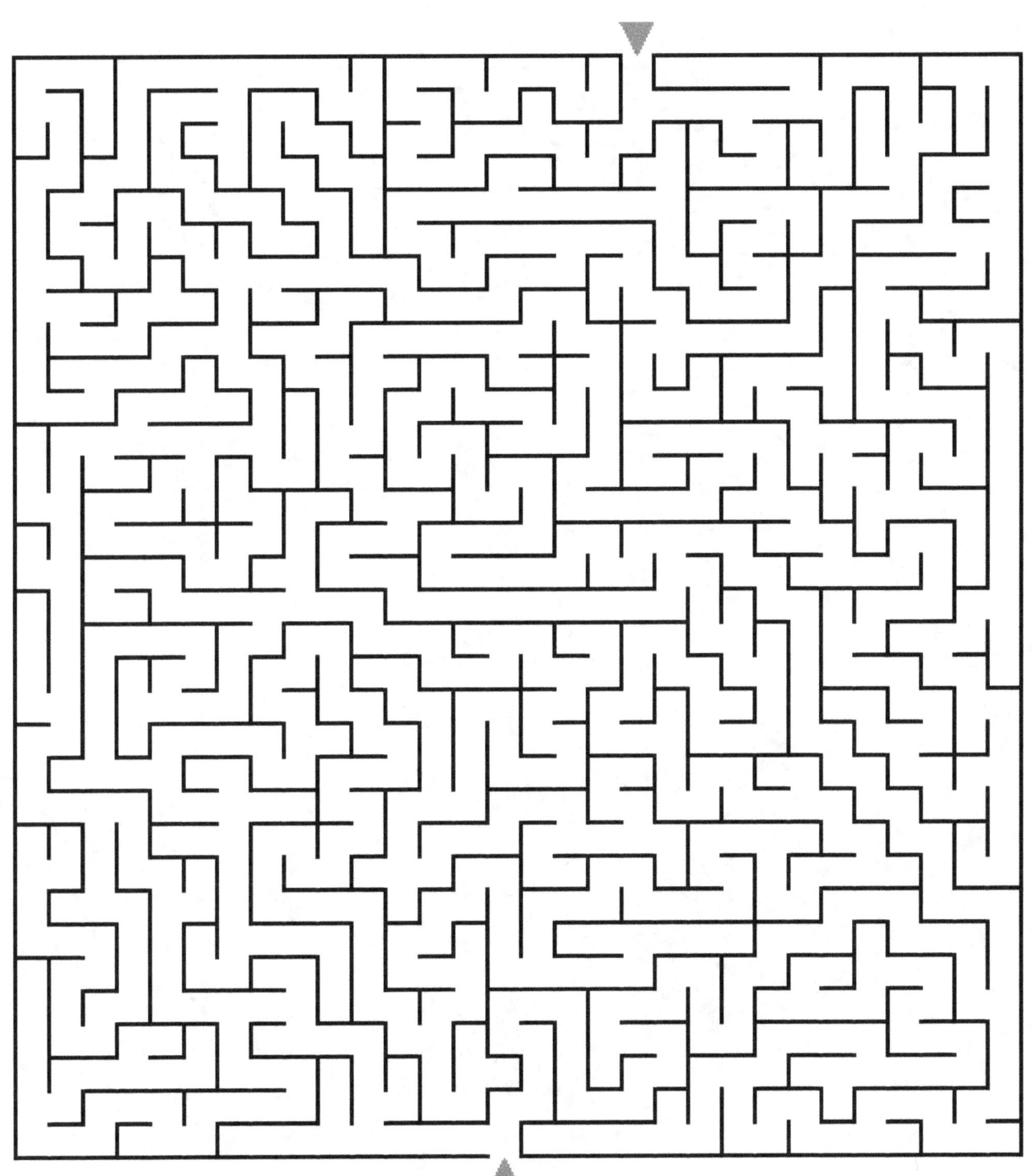

COLOR CHARTS

Solution

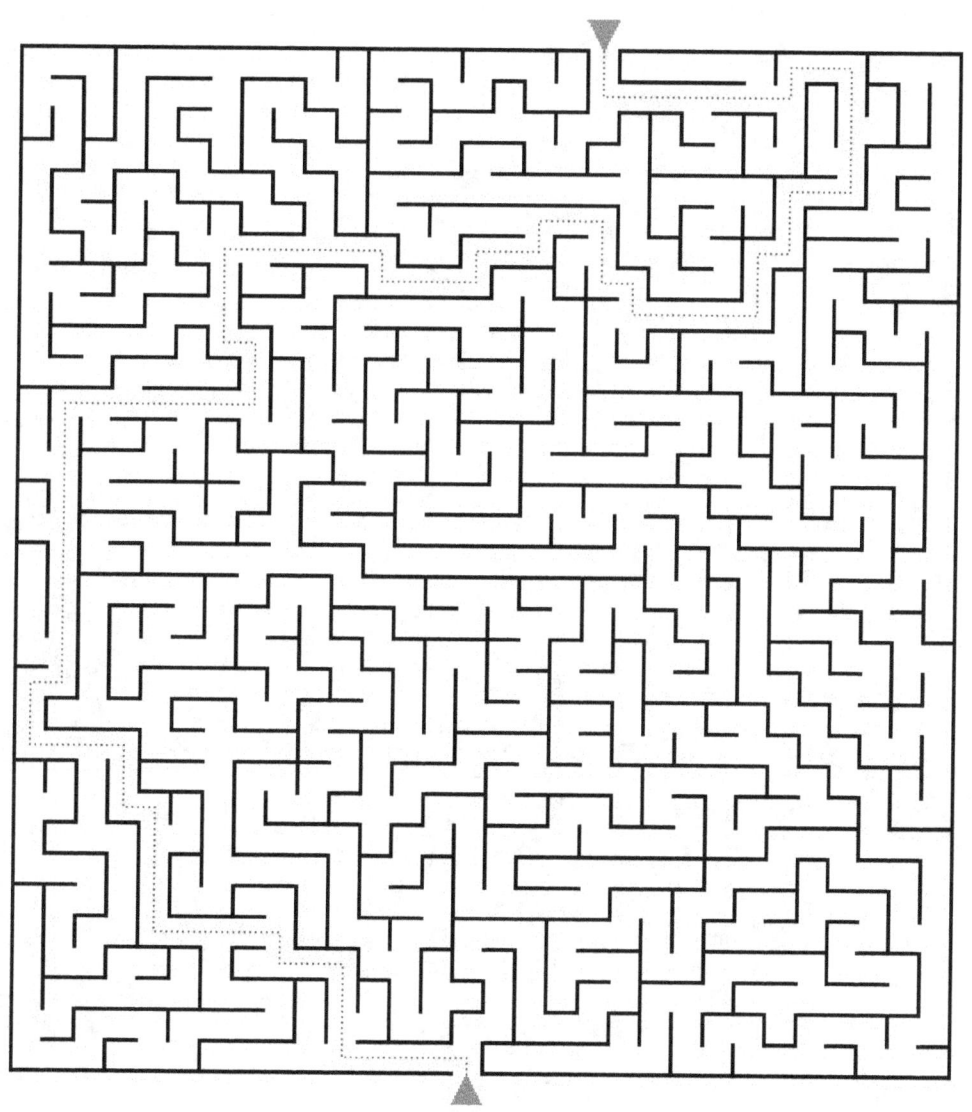

www.ingramcontent.com/pod-product-compliance
Lightning Source LLC
Chambersburg PA
CBHW081453220526
45466CB00008B/2618